Flipping
Brilliant

A Penguin's Guide to a Happy Life

Images by Jonathan Chester
Words by Patrick Regan

**Andrews McMeel
Publishing, LLC**

Kansas City • Sydney • London

Andrews McMeel Publishing, LLC
an Andrews McMeel Universal company
1130 Walnut Street, Kansas City, Missouri 64106

www.andrewsmcmeel.com

12 13 14 15 16 SDB 10 9 8

ISBN: 978-0-7407-7229-0

Library of Congress Control Number: 2007939835

ATTENTION: SCHOOLS AND BUSINESSES
Andrews McMeel books are available at quantity discounts with bulk purchase for educational, business, or sales promotional use. For information, please e-mail the Andrews McMeel Publishing Special Sales Department: specialsales@amuniversal.com

Introduction

Anyone who says penguins can't fly has never seen them underwater. In the ocean, penguins are transformed. Their short, flat wings—all but useless on land—serve as powerful flippers. Their comically tubby bodies become streamlined torpedoes. They soar, glide, dart, and dive. In essence, they do whatever they care to do. They are completely in their element.

It's a lesson worth learning: Every species—and every member of that species—excels at something. You need only find the right conditions to make life a truly brilliant experience.

This little book contains some extraordinary photos of penguins in their natural habitat, but it is not a book about penguins. Instead, this book is about another oddly endearing flightless biped. Namely, us. We, too, sometimes stumble and occasionally look awkward, but nonetheless have the innate ability to soar.

A penguin's approach to life is intuitive, practical, and cooperative. It also seems, at times, undeniably joyful. As this little book shows, we can learn a lot from these fat, feathered fellows at the bottom of the world.

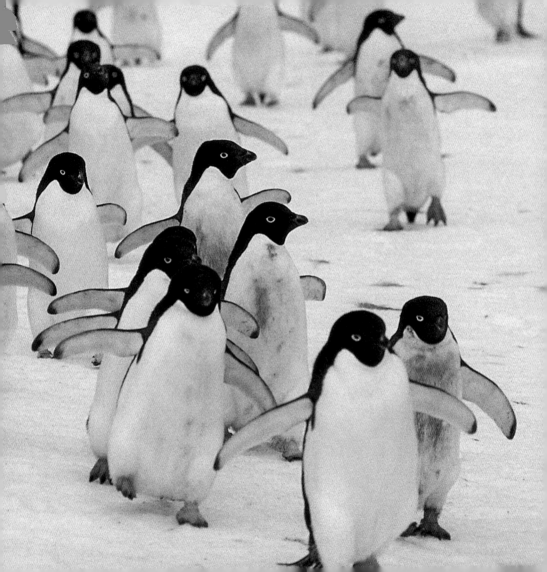

Life is not
black and white.

There are two kinds of penguins: the white ones coming toward you and the black ones going away from you. That probably qualifies as the oldest joke in the Antarctic. It's not true, of course. There are actually seventeen kinds of penguins, and most have at least a bit of color. It's tempting sometimes to see the world in black and white and to take unwavering positions about right and wrong. But things are seldom that simple, and it's life's full spectrum—of colors, emotions, philosophies, and ideas—that make it so worth living.

Stand up for yourself.

There's no denying it. The world can be an unfriendly place. There are brutes, bullies, and bad guys out there, and sooner or later, everyone runs into someone with whom reasoned conversation is not an option. Stand up for yourself—even if it means getting knocked down once in a while. More often than not, you'll find that a bully's heart doesn't match his bluster.

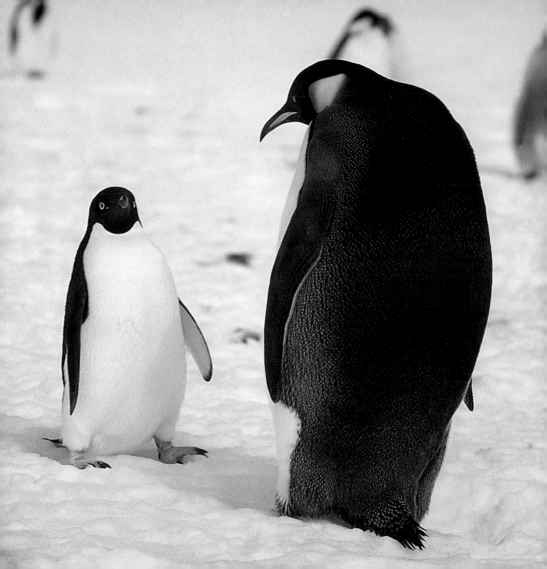

When everyone

looks the same,
look deeper.

Penguins have always been a favorite of cartoonists, and the joke is usually a variation on the same theme: they all look alike. Fine. To us, penguins of the same species do look very similar, but *they* can tell one another apart—by sound, touch, sight, and other ways biologists haven't quite figured out. Truth is, stereotypes don't work with penguins any better than they do with people.

The meek
sleep alone.

When penguins wish to attract the attention of a potential mate, they stand bolt upright, pull their flippers back, and bellow skyward. A corollary behavior frequently seen in human colonies involves an early-adult female teetering on a barstool and bellowing, "I am sooo drunk!" Among penguins, the behavior is called "an ecstatic display." Among humans, it is commonly known as "the Daytona mating call."

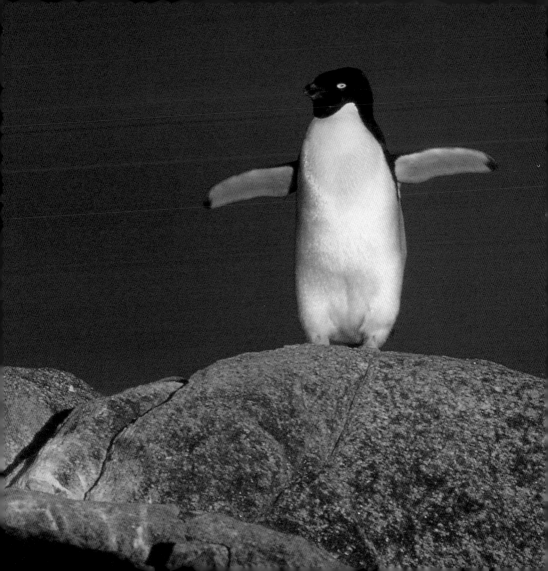

Kids learn infinitely more from how we act than from what we tell them.

Until we learn to translate their various calls, whistles, and trills, what penguin parents say to their chicks will remain a mystery. But observation tells us that penguin offspring learn all the important life skills—foraging, swimming, navigation, avoiding predators—by modeling their parents' behavior. A helpful reminder when you have chicks of your own—our actions will always speak louder than our words.

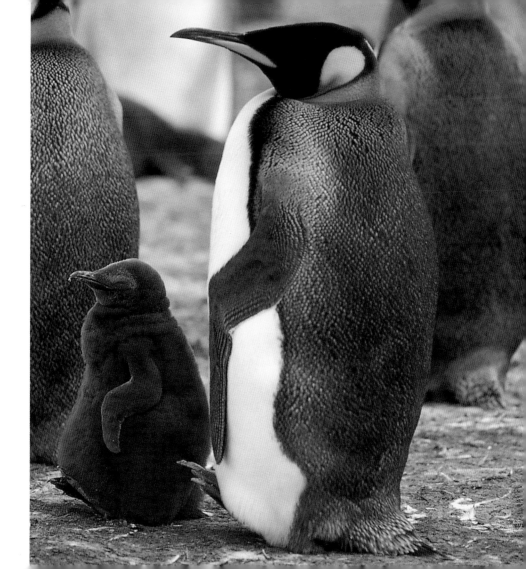

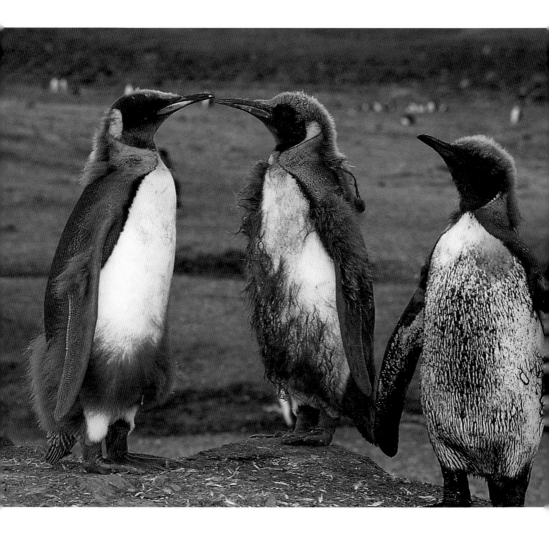

Transitions are
a bummer.

At the last stage of adolescence, a penguin chick's fluffy feathers are replaced by waterproof adult feathers. Within a period of a few weeks, the sub-adult transforms from one of the cutest, cuddliest creatures on Earth to a mangy mutant. Anyone who's lived through junior high can relate.

You *can* be
too thin.

If the Olsen twins ever get locked in a walk-in cooler for two days and are forced to live off their own body fat, they're goners. Penguins? They're good for months. A little extra baggage comes in handy once in a while.

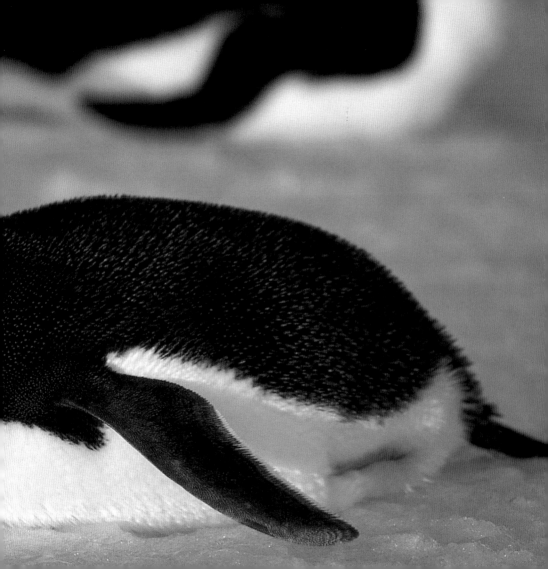

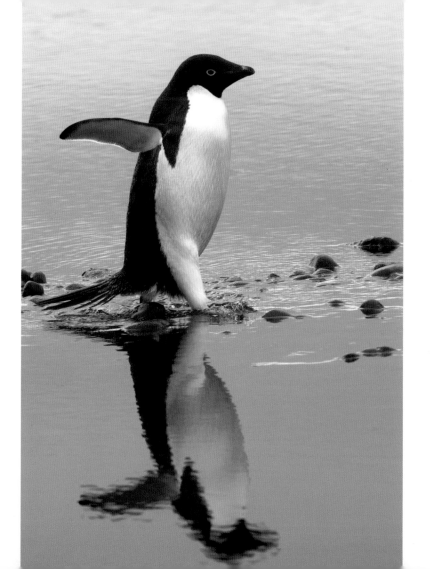

You'll never
go wrong with
basic black.

The classic black tuxedo. The little black dress. In a world that's always chasing trends and this season's hot color, black is rock solid. It's the go-to hue when an impression simply must be made.

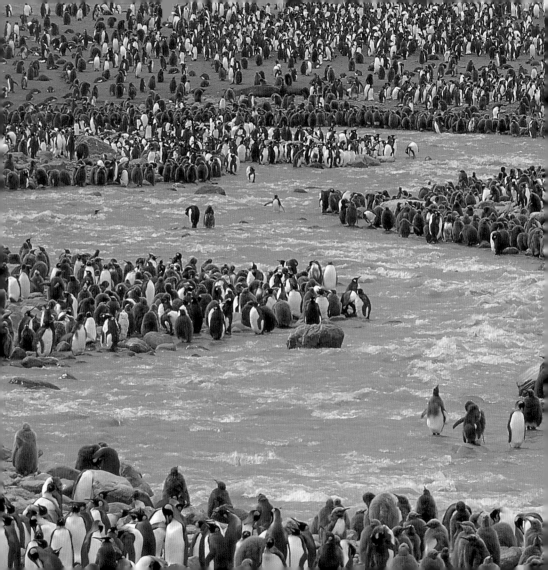

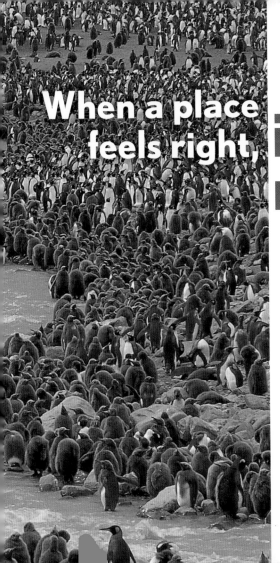

When a place feels right, it is right.

Most migratory penguins return to the same rookery, or breeding and nesting ground, year after year. Some species travel hundreds of miles to get there. The rookery is noisy, crowded, ankle-deep in penguin poop, and sorely lacking in privacy, but it's home. And as Dorothy instructed so long ago, there's no place like it.

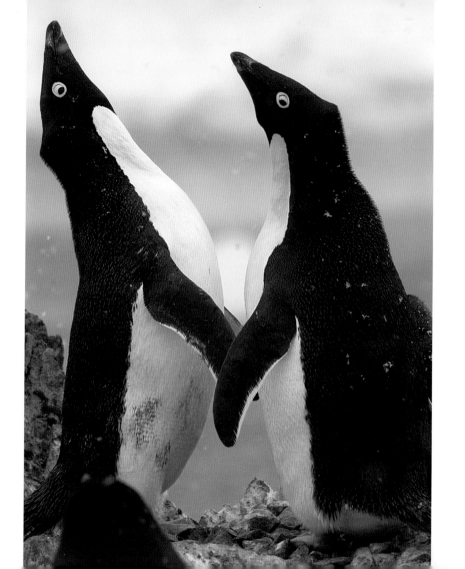

Listen
to your partner.

Many penguin pairs mate for life. That means that each nesting season, they return to the same rookery and must find their partners among thousands of birds wearing the exact same outfit. How do they do it? When first pairing up, they sing a duet and learn to distinguish their mate's voice from all others. Imagine Sonny Bono landing on an island inhabited by thousands of Cher impersonators. He wanders around singing "I Got You Babe" until someone joins in on pitch and right on cue. That's pretty much how it works.

It's what you do when no one's watching that counts.

We all know what penguins do, right? Stand around on frozen ground in big groups. Waddle back and forth to the sea. But for penguins, that's the proverbial tip of the iceberg. Most penguins spend at least 60 percent of their lives swimming in the ocean, diving for food, and trying not to become food for a predator. They do all of this to ensure the survival of their species—to feed their young and to pass along their genetic material. They only stand around when the documentary film crews are there.

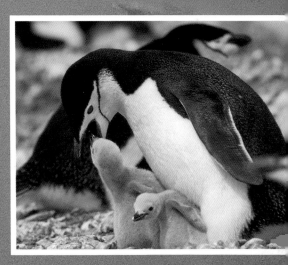

Someone has got to go first.

Adélie penguins crowd around a ledge of sea ice. The water below teems with nutritious krill and fish. The penguins pace. They peek. They hesitate. They know that there may be something else also lurking below the surface—a natural-born penguin killer called the leopard seal. Finally, one bird dives in. If it survives, the others follow en masse. It takes courage to be a leader. Are certain birds predisposed to take the plunge, or are they just unlucky enough to get pushed? We don't know, but we do know that if no one leads, none will follow and all will go hungry.

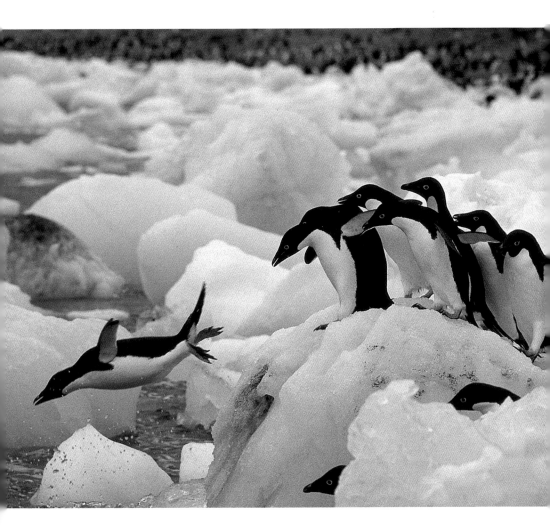

A day at the beach can cure a

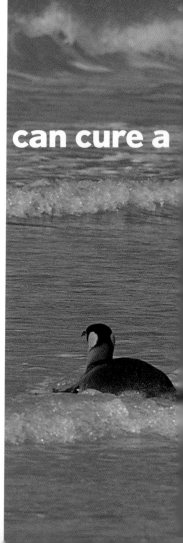

Ever notice that there are no psychiatrist offices at the beach? For penguins, the sea is for hunting, and the ground is for mating and nesting. The small strip in between, then? Well, maybe that's where they decompress for just a few moments and take a break from the exhausting cycle. There's nothing like a little sun and salt air to readjust your attitude and refresh a body for the daily trials ahead.

vast array of ailments.

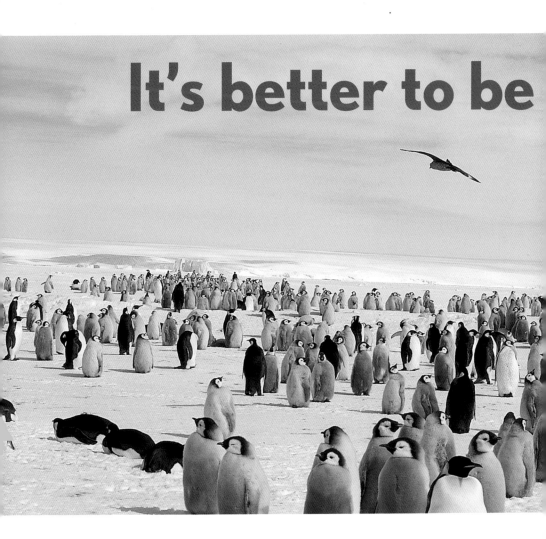

It's better to be

smart than cute.
(And best to be both.)

Penguin chicks are adorable. But south polar skuas, predatory birds that ply Antarctic skies, don't love them for their looks. After emperor chicks hatch, their parents take turns caring for their young and returning to the sea to feed. After several months, both parents take to the sea to enjoy a rare meal out together. With only a few adults left behind as caretakers, the chicks instinctively know that their best chance at survival is to form a nursery group, or crèche. Should the chicks stray too far from the crèche, the skuas make it unlikely that they'll return. After all, the skuas, though not nearly as cute, are hungry, too. And in nature, it's the strong—and the smart—that survive.

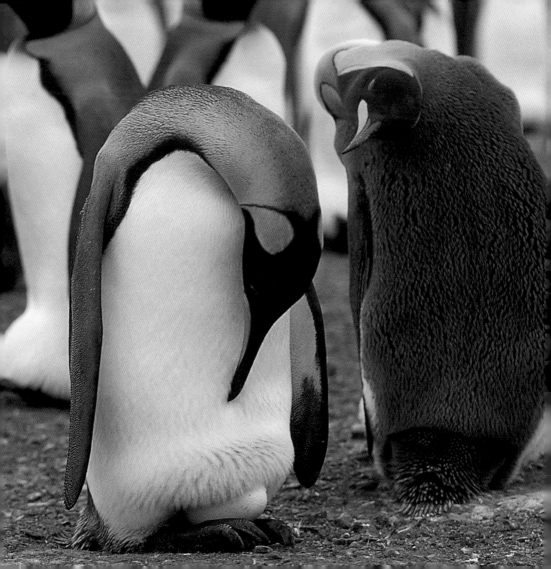

Despite all evidence to the contrary, kids are generally worth all the trouble.

We struggle to balance work and family time. King penguins struggle to balance their eggs on their feet for nearly two months before hatching. Every parent makes sacrifices for their kids. Try finding one who says it isn't worth it.

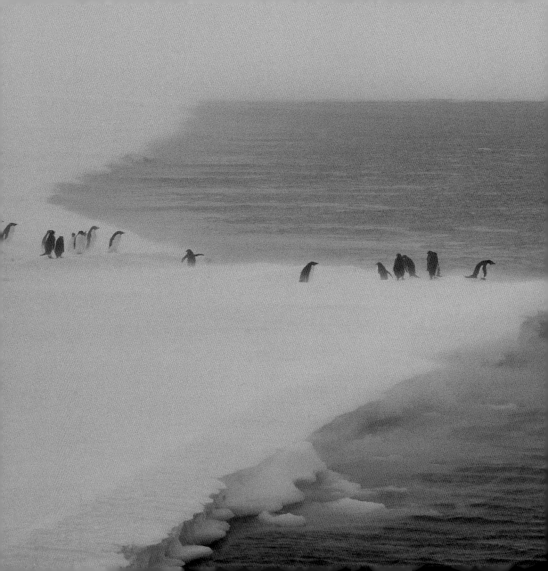

Determination
makes all the
difference.

Ever feel like the wind is always at your face? At Commonwealth Bay, Antarctica, blizzard-condition winds routinely top 100 miles per hour. At ten to twelve pounds each, it's a wonder resident Adélie penguins aren't all blown into the sea. The truth is, sometimes keeping your feet is a matter of sheer will.

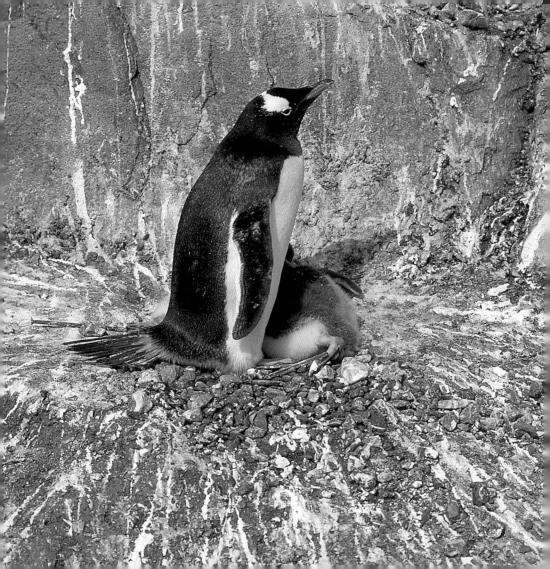

Guano happens.

Into every life, some, uh, fertilizer, must fall. And sometimes it seems to fall by the bucketful. What matters most is how you deal with the inevitable when it comes your way. For African penguins, guano makes an ideal nesting material. For gentoos (pictured here), it's more of a décor statement. It's what you do with life's little unexpected gifts that counts.

Don't always follow the crowd,

but do believe in the

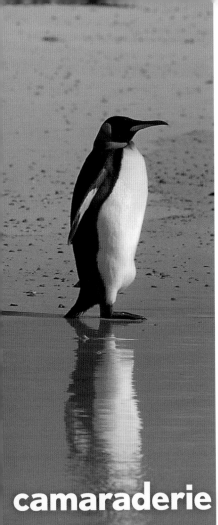

We all need our time alone, but there will always be a particular magic in sharing a moment with a larger group. Whether it's the thrill of cheering for the same team, the joy of singing the same song, or the wonder of watching a fireworks display burst overhead, there's an undeniable power in belonging, even briefly, to something larger than ourselves.

camaraderie of kindred souls.

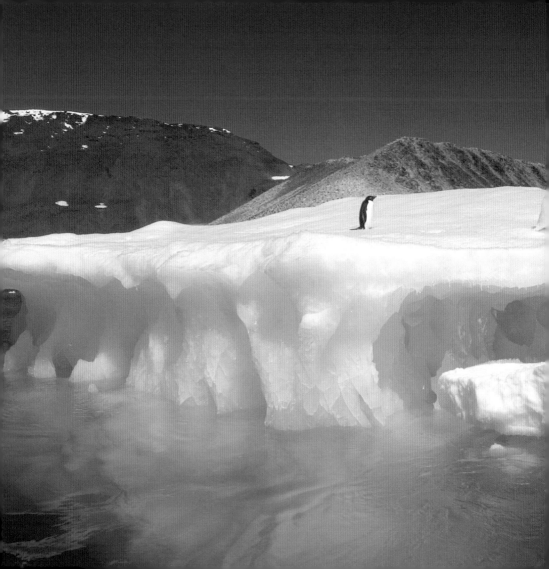

Some things we will **never** understand.

Whether mysteries of the universe or of the heart, there are forces in our lives that defy easy explanation. Continuous exploration of these forces is admirable and encouraged, but there is also wisdom in the phrase, "It is what it is."

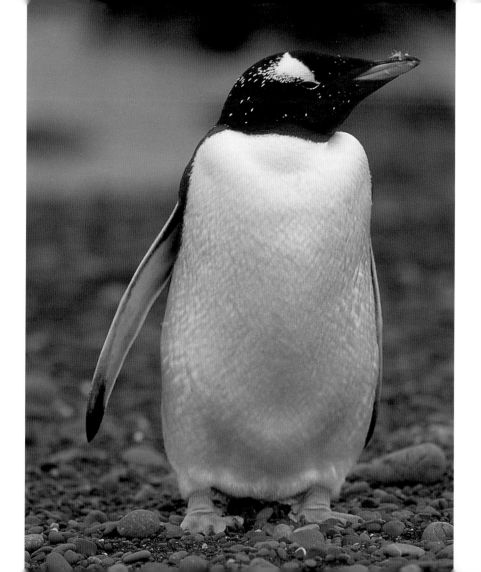

Learn to be still.

Penguins would make excellent Zen Buddhists. Surely no animal can match their ability to achieve perfect stillness in the face of conditions that are the antithesis of calm. When it comes to nesting and brooding, this ability to be still means nothing less than survival of the species. When stakes are high, living creatures are capable of extraordinary feats.

Think ahead.

The great march made by emperor penguins from the sea to their nesting grounds is rightly admired as an example of will and determination. What's often forgotten is the reason why these birds choose to incubate and raise their chicks so far from the sea. The emperors instinctively know that when spring begins, the shelf ice will begin to melt toward them. Evolutionary trial and error has taught them that if they're not far enough from the sea, the ice may grow too thin to support them while they're still supporting their eggs. There's no substitute for foresight and experience.

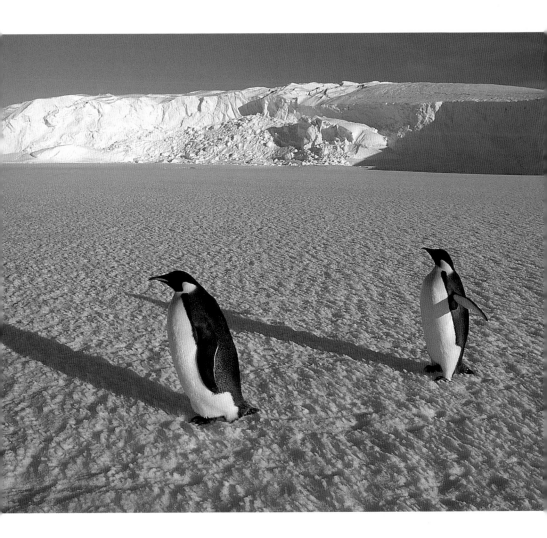

Uphills

don't
last
forever.

It's a lesson all of us learn in sixth-grade science, but few of us remember to apply to life. Energy can't be destroyed—it only changes form. Every step uphill is a down payment on an effortless glide downhill sometime in the future. Penguins are masters at energy conservation, but they also know that life regularly requires exertion. The trick, as with most things, is balancing the two.

Parenting is a
two-person job.

For penguins, child rearing is a tag-team affair. One watches over the egg or offspring while the other brings back food for the brood. Since penguins nest on land and hunt in water, there's simply no other way to make it work. Gentoo penguins share incubation duties, swapping places on the nest daily. Fortunately, among other animal species—ours included—it's possible to raise a child alone, but as any single parent will tell you, it certainly isn't easy.

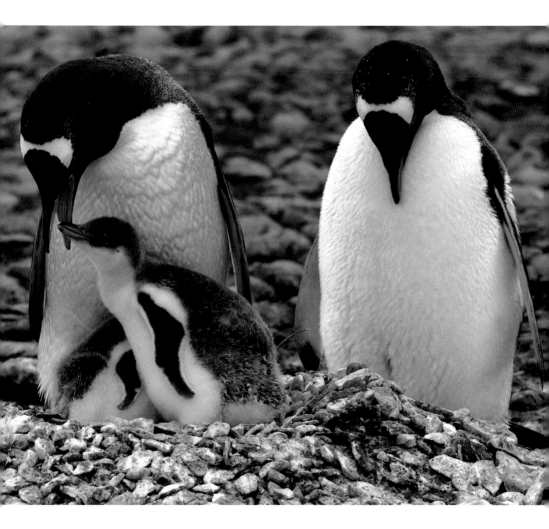

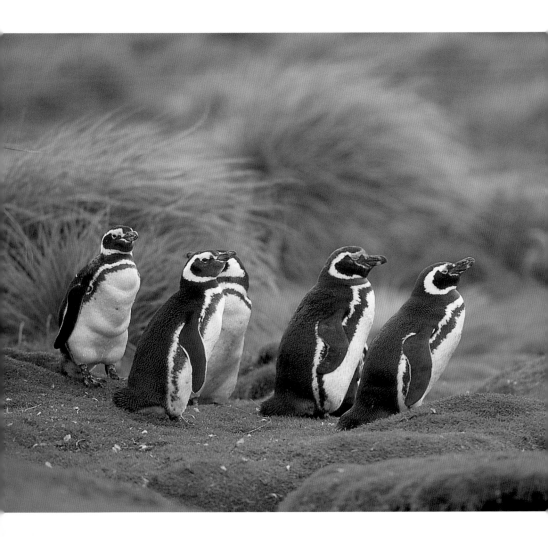

Adaptation is
survival.

Though cold-climate penguins, like the Adélie, chinstrap, and emperor, seem to have better PR agents, there are lesser known species like Galapagos and Humbolt penguins that actually thrive in tropical seas. Countless small evolutionary adaptations have given rise to seventeen distinct species of penguin. Had they

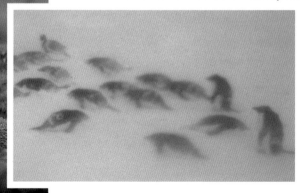

not adapted over the millennia, there would likely be no penguins left at all—all of which serves as a nice little reminder that we can roll with the changes, or have changes roll over us.

Work
with nature.

A penguin's countershading serves as a built-in personal thermostat. If he's cold, he turns his black back to the sun to warm up; if he's hot, he lets his white front reflect the sun's rays. Penguins, with their walnut-sized brains, have mastered solar energy. What's holding us back?

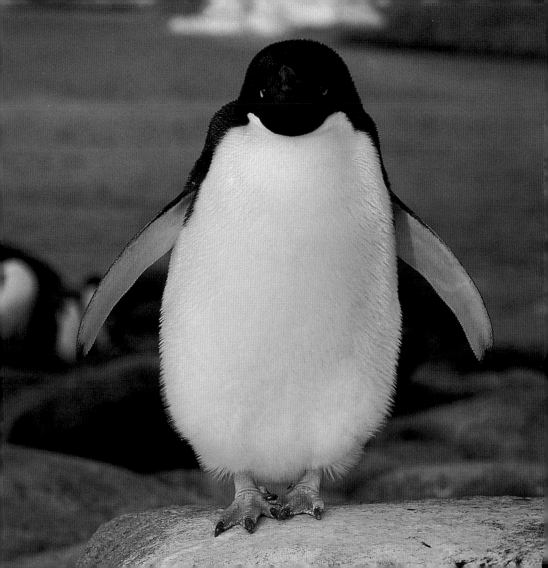

Be an
original.

There have been countless imitators, but there's a reason the Beatles will never be forgotten. Find your own road.

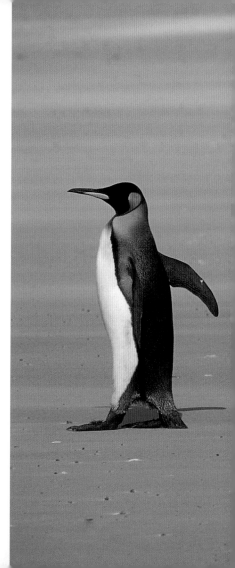

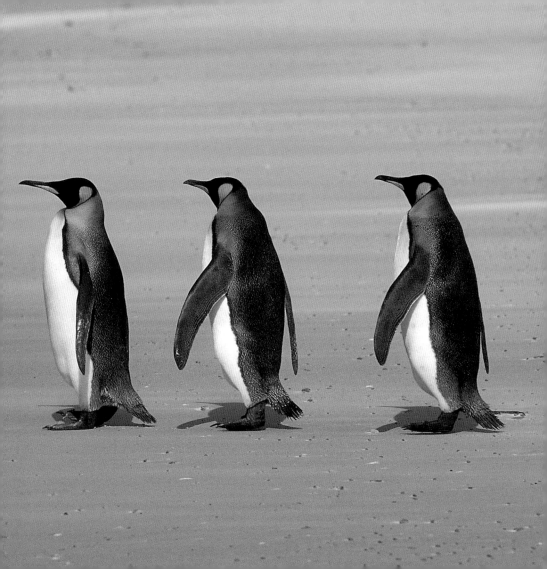

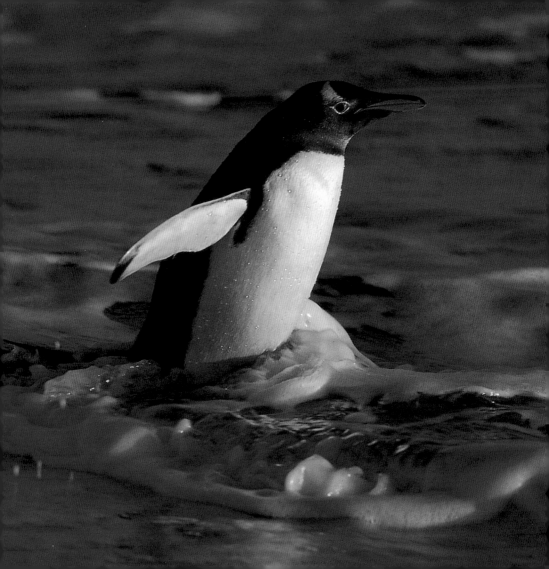

Life is an adventure.
Live accordingly.

On any given day, a penguin may enjoy a hearty meal—or become one. For a penguin, the sea is life, and there's no way of knowing what's just below the surface until breaking it. Such is life in the middle of the food chain. It's often exhilarating, sometimes frightening, and ultimately (like it or not) fatal. So what's a chubby bird to do? Be fruitful and multiply, or be fearful and calcify? There's only one answer for him as there is for us: Dive into life and fly.

Image Key

Front Cover
Chinstrap penguin
Pygoscelis antarctica
Baily Head, Deception Island
This elegant species nests by the hundreds of thousands on the South Shetland Islands at the tip of the Antarctic Peninsula.

Page 6
Adélie penguins, *Pygoscelis adelie*
Davis Station, Antarctica
Adélies were first described on French explorer Admiral Dumont d'Urville's 1841 expedition and were named in honor of his wife, Adélie.

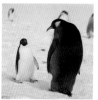

Page 7
Adélie penguins
Commonwealth Bay, Antarctica
Adélies are found all the way around the Antarctic continent and on neighboring islands, but they are rarely seen beyond the Antarctic convergence, the northern limit of colder water.

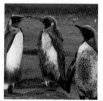

Page 9
Adélie penguin (l.) and emperor penguin (r.), *Aptenodytes forsteri*
Auster Rookery, Antarctica
These are both true Antarctic species breeding on the Antarctic continent. Adélies breed in the brief summer, while the emperors breed in the winter.

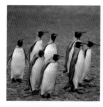

Page 10
King penguins, *Aptenodytes patagonica*
South Georgia
Kings, the second-largest penguin, are a very social species that breed in vast rookeries on sub-Antarctic islands, including South Georgia, Macquarie, and the Crozet Islands.

Page 13
Adélie penguins
Commonwealth Bay, Antarctica
Adélies build rudimentary nests of pebbles on rocky outcrops. The males will defend their territory against other birds trying to steal their pebbles.

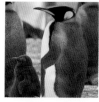

Page 15
King penguins
South Georgia
It is difficult to tell male from female adult king penguins, but adults and chicks look so different, early explorers thought they were two different species.

Page 16
King penguins
South Georgia
King penguins have the longest fledging stage (thirteen months), and because of this adults can have only two chicks in a three-year cycle.

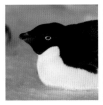

Page 19

Adélie penguin

Commonwealth Bay, Antarctica

All penguins have the ability to bulk up for breeding and molting. When Adélies leave the colony after molting, they will have lost almost half their body weight.

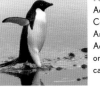

Page 20

Adélie penguins

Couverville Island, Antarctic Peninsula

Adélies are the archetypal "black on top, white below" penguins. This camouflage is called countershading.

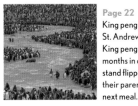

Page 22

King penguins

St. Andrews Bay, South Georgia

King penguin fledglings spend months in crèches, where they stand flipper-to-flipper waiting for their parents to bring them their next meal.

Page 24

Adélie penguins

Commonwealth Bay, Antarctica

Penguins depend on identifying the distinctive sound of their partners and young. Thus, their ritual, called bobbing and flapping, is vital to successful mating and reproduction.

Page 26

King penguin

Macquarie Island

Unlike other birds that dive into the sea by paddling their feet, penguins literally "fly" underwater, using their flippers to propel themselves, just as most other birds do in a less dense medium—air.

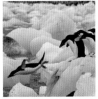

Page 27

Chinstrap penguins

South Shetland Islands, Antarctica

Adult penguins regurgitate fish and krill from their feeding expeditions directly into the bills of their young soon after returning to the nest.

Page 29

Adélie penguins

Davis Station, Antarctica

Adélies face the threat of patrolling leopard seals most times they enter the sea. The mass entry affords them a degree of safety.

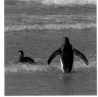

Page 31

King penguins

Falkland Islands

Penguins spend most of their lives at sea, coming ashore only to breed and molt. With stubby legs, they are awkward on land but in the water they are graceful and perfectly adapted.

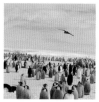

Page 32
Emperor penguins
Auster Rookery, Antarctica
Polar penguins, such as the emperor and the Adélie, have no land predators, so they nest and rest on ice with impunity. Their biggest threat is the most-southerly flying bird, the skua.

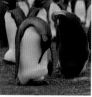

Page 34
King penguins
South Georgia
Kings breed in vast colonies and require relatively flat ground, because they balance their one egg on their feet until it hatches.

Page 36
Adélie penguins
Commonwealth Bay, Antarctica
These birds easily endure extreme cold and violent winds in the place that was named "The Home of the Blizzard" by early Australian explorer Sir Douglas Mawson.

Page 38
Gentoo penguins, *Pygoscelis papua*
Antarctic Peninsula
The color of a penguin's guano is a good indication of what it has been eating. Krill gives it a reddish tinge, while a diet of fish and squid leaves it more bleached.

Page 40
King penguins
Falkland Islands
At 37·½ inches (95 cm) in height, the king is the second-largest of the seventeen recognized penguin species. They are easily identified by their bright orange comma-shaped ear patch.

Page 42
Adélie penguins
Paulet Island, Antarctic Peninsula
On this remote island, on the eastern side of the Antarctic Peninsula, Adélies were food for stranded Swedish explorers from Nordenskjöld's 1901–04 expedition.

Page 44
Gentoo penguin
Falkland Islands
Penguins can sleep standing up, often seeming like statues as they conserve energy.

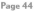

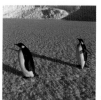

Page 47
Emperor penguins
Auster Rookery, Antarctica
There likely are fewer than 200,000 emperor penguin pairs located in forty-two known colonies distributed at high latitudes (66° to 70°S) around the Antarctic continent.

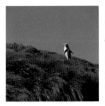

Page 48
Yellow-eyed penguins
Megadyptes antipodes
Enderby Island, New Zealand
Yellow-eyed penguins are the only
solitary species. Roosting in low shrubs
makes them vulnerable to predators
such as cats and dogs.

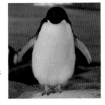

Page 55
Adélie penguins
Commonwealth Bay, Antarctica
With a layer of fat and dense
feathers, Adélies easily overheat. To
cool off, they fluff up their feathers
and stand with flippers akimbo to
maximize heat loss.

Page 51
Gentoo penguins
Antarctic Peninsula
Gentoos, like the other "brush-
tailed" species, Adélie and chinstrap,
often will lay two eggs, but rarely
does a second chick survive.

Page 57
King penguins
Falkland Islands
King penguins, true to their name,
comport themselves in a regal
fashion. Their stateliness, beautiful
mating ritual, and gregariousness
make them a delight to observe.

Page 52
Magellanic penguins
Spheniscus magellancius
Falkland Islands
This species was first described in
1591 by the Italian naturalist Antonio
Pigafetta, who named them for his
expedition leader, Ferdinand Magellan.

Page 58
Gentoo penguins
Falkland Islands
Gentoos are easily identified by their
white-speckled eye band of feathers,
bright orange bills, and pinkish-
orange feet.

Page 53
Adélie penguins
Commonwealth Bay, Antarctica
As with the ability to restrict circula-
tion to their feet, Adélie's have many
behavioral and physiological adapta-
tions that enable them to survive in
the most extreme conditions.